SUSIE COC

Alan Marshall

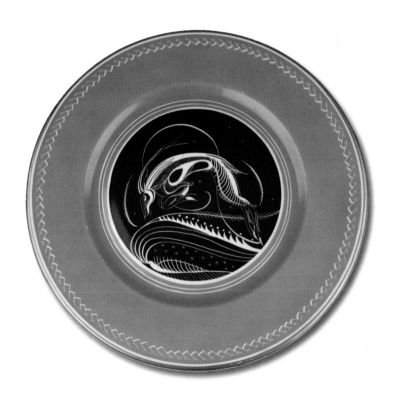

SHIRE PUBLICATIONS

Published in Great Britain in 2013 by Shire Publications Ltd,
Midland House, West Way, Botley, Oxford OX2 0PH,
United Kingdom.

43-01 21st Street, Suite 220B, Long Island City, NY
11101, USA.

E-mail: shire@shirebooks.co.uk www.shirebooks.co.uk

A CIP catalogue record for this book is available from the
British Library.

Shire Library no. 719. ISBN-13: 978 0 74781 213 5

Alan Marshall has asserted his right under the Copyright,
Designs and Patents Act, 1988, to be identified as the
author of this book.

Designed by Tony Truscott Designs, Sussex, UK
and typeset in Perpetua and Gill Sans.

Printed in China through Worldprint Ltd.

13 14 15 16 17 10 9 8 7 6 5 4 3 2 1

COVER IMAGE
A group of Susie Cooper designs spanning much of her
career, ranging from Gray's Pottery pieces from the 1920s,
through transfer-printed decoration on the Kestrel shape
in the mid-1930s, to her Quail bone-china form of
the 1960s.

TITLE PAGE IMAGE
A striking illustration of highly detailed sgraffito
decoration in the form of a leaping antelope on
a place-setting platter from the 1930s.

CONTENTS PAGE IMAGE
A hand-painted floral design known as Nosegay on a
divided vegetable-serving dish, from the earliest days of
Susie Cooper Productions in 1931. The pattern reappeared
in the mid-1930s as a transfer-printed motif.

ACKNOWLEDGEMENTS
All photographs were taken by Alan Marshall, and all items
photographed are the personal property of Alan Marshall
and Marion Scott.

Shire Publications is supporting the Woodland Trust, the UK's leading woodland conservation charity, by funding the dedication of trees.

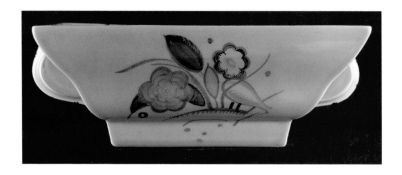

CONTENTS

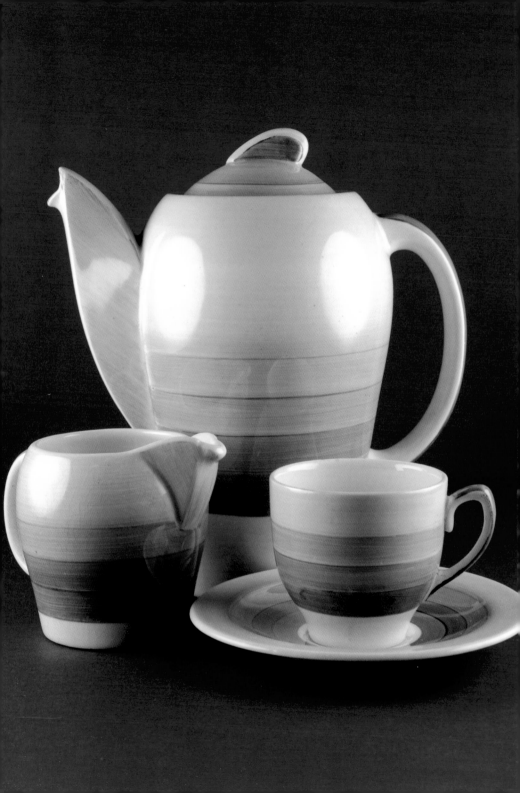

INTRODUCTION

FOR A SHORT PERIOD in the late 1920s and early 1930s the careers and styles of Susie Cooper and Clarice Cliff overlapped. This has resulted in Susie being unfairly pigeon-holed as just another Art Deco designer daubing bright colours on to tea and coffee pots. In the opinion of many, however, no other artist in her field can begin to compete with Susan Vera Cooper in terms of patterns introduced, shapes created, techniques developed, careers influenced and barriers broken.

During her ninety-three-year life and sixty-year career, Susie is believed to have launched at least 4,500 ceramic designs. She moved from striking but primitive hand-painting, through delicate wash-banding and precise lining, to aerograph techniques, incised decoration and sophisticated lithographic transfer printing. Her design of the classic 'can' shape of coffee cup remains with us and has been used by virtually every tableware manufacturer. Her Leaping Deer maker's mark became instantly recognisable and is an Art Deco icon, while the Kestrel family of tea and coffee wares was in production for three decades and is unrivalled in its elegance and functionality.

Kestrel was launched at the British Industries Fair (BIF) in London in 1932. This bold, stylish and practical design was to establish Susie Cooper as a major force in British ceramics. At the time she was not yet thirty years old, but she was already championing the cause of women in the Potteries, not just as designers but also as factory managers.

Her career in clay had begun a decade earlier when she joined Gray's Pottery in 1922 and started creating decorative designs for bought-in domestic wares. The ambitious twenty-year-old was not content simply to paint other people's pots but yearned to get her own designs accepted. The move in 1929 from Gray's to form her own company reflected a conviction that she could marry her striking patterns with purpose-made shapes and create something entirely new. Susie Cooper therefore led the charge of gifted female designers in the male-dominated Potteries, clearing the way for Charlotte Rhead, Millicent Taplin and stars of future generations such as Kathie Winkle, Jessie Tait and Sally Tuffin.

Opposite:
A sequence of soft colours in concentric rings was applied to tableware produced in the early 1930s. The design was popular as a gift for newlyweds, becoming known as Wedding Ring, shown here in the blue variant.

Susie Cooper's Leaping Deer logo was applied by transfer to most of the earthenware output well into the 1950s. It exemplifies the blending of her love of nature with her precise draughtsmanship.

The Kestrel family of tea and coffee wares was introduced in 1932 but was to remain in production for almost three decades, bearing all forms of Susie Cooper decoration.

In the Art Deco era, Susie had been initially keen to adopt the highly coloured and bold geometric designs that were appearing on imported Czech pottery. These hand-painted 'Jazz Age' patterns are still prized by today's collectors, but they quickly lost their appeal to Susie herself as she developed a taste for more sophisticated decoration. As far as Susie was concerned, the abstract designs were created for purely commercial reasons. She believed them to be fashionable and was certain that they would sell, but she did not much like the crude, heavy patterns painted on a random selection of shapes. They offended Susie's

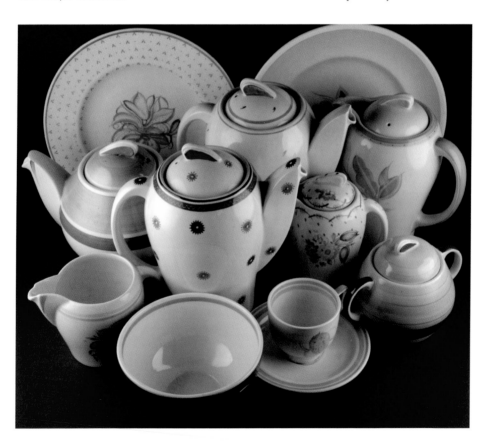

desire to supply a high-quality, durable product, and she was happy to leave the Jazz Age behind.

Two key areas of decoration arguably define Susie Cooper's work and underpinned the success of her tableware shapes such as Kestrel, Falcon and Rex: the use of innovative banding techniques, and her application of sophisticated floral lithographic motifs.

In the mid-1930s Susie's wash-banded ceramics enjoyed remarkable success, culminating in the Wedding Ring design, a long-term favourite with the public. The success of these designs spawned many imitations, and Susie's team moved from broad-banded designs to narrower horizontal decoration in autumnal colours, the

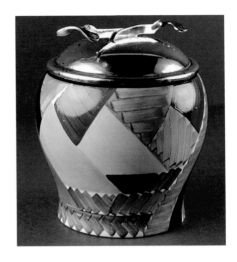

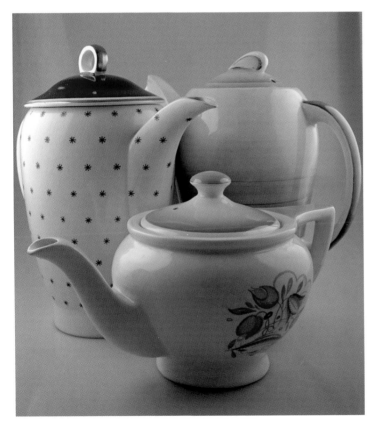

Hand-painted 'Jazz Age' patterns designed for Gray's Pottery in the 1920s are still prized by today's collectors, but they quickly lost their appeal to Susie Cooper herself as she developed a taste for more sophisticated decoration.

Two key areas of decoration define Susie Cooper's work and underpinned the success of her tableware shapes such as Kestrel, Falcon and Rex. They are the use of innovative banding techniques, and the application of sophisticated floral lithographic motifs.

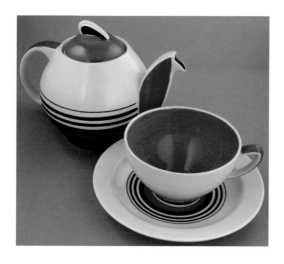

so-called Crayon Line. Polka Dot was another popular pattern that inexperienced paintresses could easily learn and effectively apply.

In the late 1930s Susie adopted elements of mass-production techniques in the form of transfer-printed outlines, which, combined with hand finishing, provided the ideal balance. In order to retain full control over the appearance of the pots, Susie took great pains in creating her own detailed artwork, and in choosing manufacturers capable of fulfilling her exacting demands. Although rather underrated today,

The enduringly popular Graduated Black Bands series was created for inexperienced decorators. When the bold solid colours were combined with the varying-width black bands on the tall coffee pots or globular Kestrel teapots, a 1930s design icon was born.

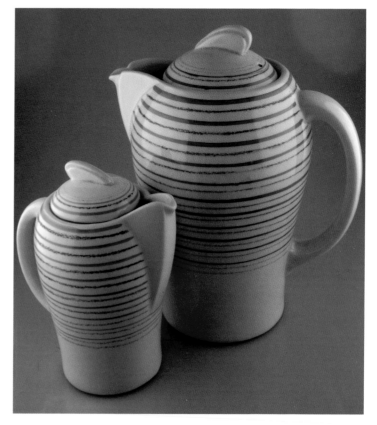

From the broad brush-stroke banded designs such as Wedding Ring, Susie Cooper moved to narrower horizontal decoration in autumnal colours known collectively as Crayon Line.

lithographic designs such as Dresden, Swansea Spray and Patricia set new standards for the British ceramic industry.

After the Second World War Susie Cooper developed her bone-china production and designed the Quail shape, which proved to be another great success. In 1966 her pottery merged with Wedgwood, although her Crown Works factory remained autonomous until the end of 1980. Then, from a new studio at William Adams in Tunstall, she continued to design as prolifically as ever. Even when she was in retirement on the Isle of Man in the 1990s, her talents as a freelance designer were still sought after, both within the ceramics industry and in other fields. Her energy and

Another familiar Susie Cooper family of patterns from the early 1930s was known as Polka Dot. Trainee paintresses could be taught the technique with ease, and the range was retailed extensively by John Lewis stores.

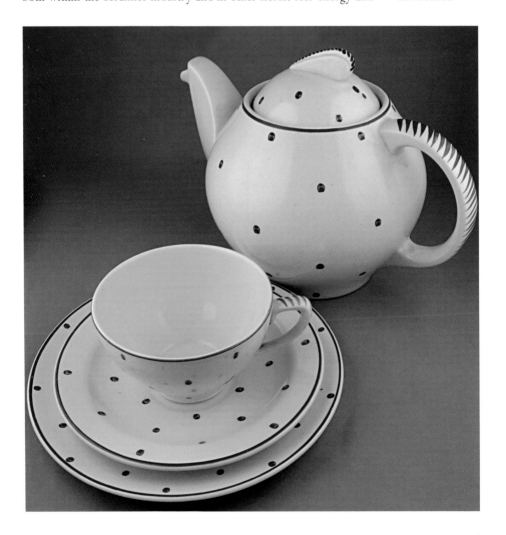

Patricia Rose is another of Susie's most famous creations. It made its first appearance in 1938, starting with an ostensibly simple pink rose design and expanding to include several colour variants.

Transfer-printed designs such as Dresden, Swansea Spray and Printemps represent highly sophisticated examples of graphic art and set new standards for the British pottery industry.

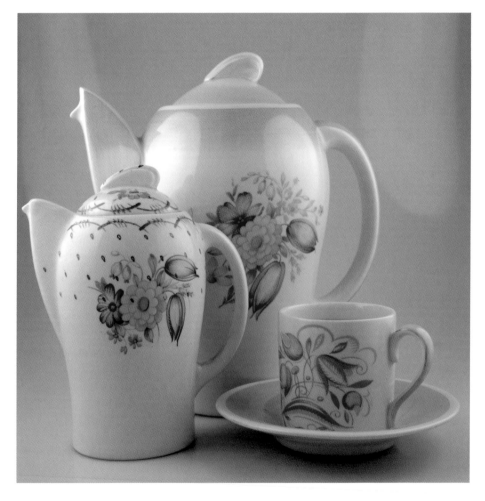

enthusiasm seemed undiminished by age or by the trials of her last few difficult years with Wedgwood.

Far too few have acknowledged the length and breadth of her career in the Potteries, her prolific and progressive output, and her lasting influence on the world of ceramics.

This book represents an abbreviated record of her remarkable achievements, providing a representative selection of her major designs, and highlighting the need for greater recognition among ceramics collectors and historians.

It is ironic, of course, that Susie hated the idea of people buying her infinitely useful wares and placing them in cabinets, in museum display cases or up on shelves to gather dust. She revelled in making pretty things for people to use every day.

After the Second World War Susie Cooper developed her bone-china production and designed the Quail shape. This organic form was decorated with stylish yet simple patterns such as Gardenia and Azalea, designed to emphasise the shape and style of the body.

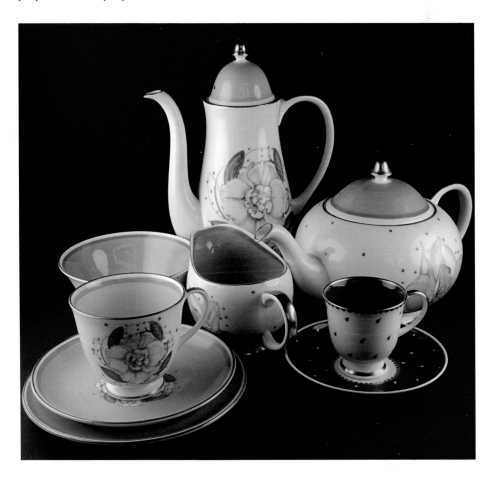

POTTERIES BORN
AND BRED

Depicted here as a limited-edition model by Kevin Francis, Susie Cooper was able to combine her childhood love of nature with artistic skills developed during her time at Burslem School of Art.

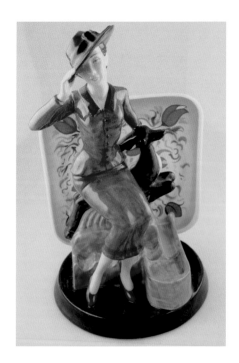

Susie Cooper was born in 1902 close enough to hear, see and smell the billowing waste from the chimneys of the six towns that later merged to become Stoke-on-Trent. In the early twentieth century this was still the heart of the British ceramics industry, and Susie spent her formative years near this great centre of ceramics manufacture.

While the Cooper household in 1902 was large, containing seven children, it was a comfortable home because of the business success of Susie's father, John. He owned a 90-acre farm in the area, had significant interests in the supply of fuel oil, and a property portfolio that provided a healthy, if not spectacular, income. Susie's early talent for drawing was therefore nurtured in a cosy environment. During her childhood, the family farm provided her with plenty of inspiration from the natural world, and this was channelled into her drawing. Susie developed a keen eye for detail, particularly when it came to plants, birds and animals.

Adding to the skills needed in her later career, Susie had an unusual interest in the business activities of her father. Showing considerable tolerance and foresight, he was more than happy to indulge her curiosity about his work. The youngest child therefore learnt early in life the basics of business, which, when combined with her obvious artistic flair, provided an excellent foundation for success in either the arts or industry.

Even for an intelligent and gifted young woman, the early twentieth century was hardly an enlightened period. Susie was expected to follow a suitably feminine career path, based

perhaps on secretarial duties before married life and motherhood. However, typing classes failed to retain her interest. At seventeen, Susie enrolled at the Burslem School of Art, paying 10s 6d each for courses in plant form and freehand painting that would occupy her for two evenings a week. The widespread use of plant and floral motifs in her later work can be traced back directly to the Burslem studies. The school was a remarkable institution that became a powerhouse of ceramic design, nurturing such talents as William Moorcroft, Clarice Cliff, Charlotte Rhead and, later, Jessie Tait and Peggy Davies.

Each of the six towns that united in 1910 to create Stoke-on-Trent had an art school, and the one at Burslem was founded in the 1850s, moving to new purpose-built premises in 1905. Clarice Cliff attended evening classes there in the 1920s, while the highly influential Gordon Forsyth, who had designed for Pilkington's Lancastrian Pottery & Tiles, had become head of the Burslem institution in 1920. He was to play a pivotal role in Susie Cooper's career development.

The great consistency and quality of her evening-class work was such that in 1920 she won a scholarship that enabled her to attend the school full-time. Under the tutelage of Forsyth, Susie flourished. She began to diversify her interests into woodcarving, etching and fabrics, many of which would feature during her professional career. Indeed, her only involvement with ceramics at this early stage concerned some hand-made figurines in earthenware and china. But for chance, her chosen path would almost certainly have been fashion design.

At the end of the Burslem course, Susie applied for a place at the Royal College of Art (RCA) in London, where she hoped to train in fabrics and fashion. To her disappointment, she was rejected because of the college's policy of not accepting students straight from art school. The RCA wanted its students to have gained experience in industry before enrolling. Given Susie's location in Stoke-on-Trent, opportunities to work in dress design were few and far between. However, after the rejection she took the advice of Forsyth and turned to the pottery industry, where she found a place with Albert Edward Gray's firm in Hanley. This was intended to be a brief stopgap: her ambition was still to create frocks, not pots.

A stylish image from the 1930s of a young Susie Cooper, here reproduced as a poster for the Wedgwood Museum.

A Portrait of *Susie Cooper*

SEVEN DECADES OF CERAMIC DESIGN

At the Wedgwood Museum and Visitor Centre, Barlaston, Stoke-on-Trent. April 20th – December 19th 1992.

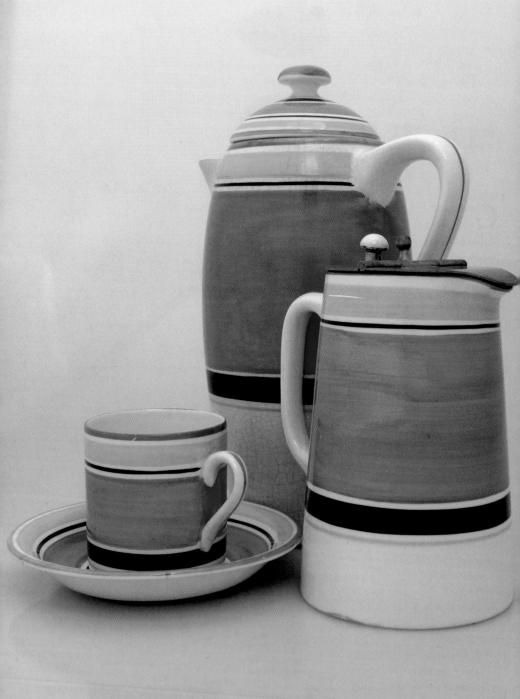

BRINGING COLOUR TO GRAY'S

G RAY'S POTTERY was a relatively young company, but its close association with Gordon Forsyth made it a good choice for Susie's first experience in the ceramics trade. Forsyth was clearly hoping that his star pupil could be persuaded to commit to a future in the pottery industry.

Edward Gray had himself moved from ceramics wholesaling to production in 1912, and the ten-year-old factory had been using a number of designers, such as George Buttle and John Guildford, to add decoration to bought-in hollow and flat ware. Gray was committed to delivering high-quality products with striking decoration. He employed talented individuals and was a well-known member of the Ceramics Society and the Design and Industries Association. He was close to the regional art schools, hence the relationship with Forsyth and his willingness to hire Susie.

While Gray employed Susie in the knowledge that she hoped to use a short period at the firm to get her into the RCA and on the fast track to fashion, he was convinced she would find ceramics fulfilling and remain part of his team. In fact, she stayed at Gray's for seven years and by then was content to turn her back on textiles.

There is no documentary evidence confirming the timing or terms of her employment at Gray's, or of what role she was supposed to play. It is now accepted that she had joined the factory in the expectation of designing for the company, thus acquiring useful experience for her next RCA application. However, Gray had earlier hired another designer and Susie therefore found herself employed as a paintress, being paid daily for the items she had decorated.

This was not part of the plan and she soon ran out of patience with her limited role. She would in later years admit that, as a humble decorator, she had developed an important understanding of what could be done with freehand decoration. She had also learnt the commercial realities of patterns that could be applied quickly and cheaply, so as to fulfil orders and deliver profitable pots.

Her persistence in pressing Gray for a more senior position paid off when there was an unexpected departure in the design department of the

Opposite:
Susie Cooper
designed only
a few tea- and
coffee-pot forms
while at Gray's.
The hand-painted
coffee pot shown
here is thought to
have been one
of her early
creations.

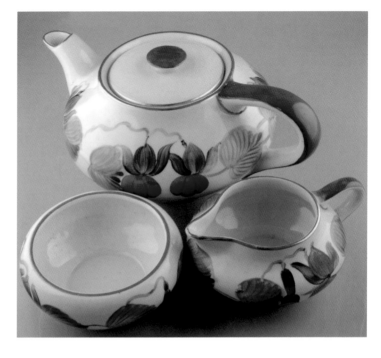

Above: Many of the earlier Gray's designs, bearing the Galleon backstamp, are attributed to Susie Cooper, but some are the work of other designers at the factory.

Right: Part of a Fuchsia pattern Gray's teaset from around 1923, hand-painted and with gilt rim.

The yellow and black Gloria Lustre mark was applied to Gray's lustre pieces in 1923–8, with a gold or bronze variant appearing in the latter part of the period.

When the Gray's Liner mark appears on the base of a pot, particularly when accompanied by 'Designed by Susie Cooper', there is no real doubt regarding the pedigree of the piece.

one-hundred-strong firm. This provided the opportunity Susie needed to make her mark. On becoming Edward Gray's head of decoration, she could at last begin to influence the look of the pottery's output. Unfortunately, she still had to live with the white wares bought in from other factories, as Gray had only a limited interest in creating fresh shapes and styles.

There are some tea- and coffee-pot forms that Susie Cooper is believed to have designed while at Gray's, but there is no confirmation in surviving paperwork. No reliable record exists of the patterns introduced at Gray's under Susie's stewardship. During her reign, more than three thousand decorating variants are believed to have left the factory. While many were Susie's work, there were also creations by Guildford, Forsyth, Jack Bond, Dorothy Tomes and by Sam Talbot, who would take over when Susie left.

According to Gray's experts, the earliest pattern number associated with a Susie design was 2,800, and the latest would have been around 8,450, taking the numbering up to October 1929, when she left to establish her own pottery. Not until her dedicated Liner backstamp was applied to the underside of the pots in 1927 is there any clear identification of Susie Cooper pieces. Many of the earlier designs, bearing the Galleon backstamp, are attributed to Susie Cooper, but the common Gray's Clipper mark was generally applied only after she had left the firm. In theory, the earliest patterns involving Susie Cooper at Gray's would have featured the black and yellow Galleon backstamp. If the pattern number falls into the 2,800–5,600 range and is marked with the Galleon, it may well be one of Susie's, but there is no certainty. After the Liner mark appeared, particularly when accompanied by 'Designed by Susie Cooper', there is no real doubt regarding the pedigree of the particular item.

Susie was definitely involved in Gray's bold use of lustre paints to achieve shiny, metallic finishes, although the Gloria Lustre range of designs is believed to have been partly the work of Gordon Forsyth during a stint at the factory. The yellow and black Gloria Lustre mark was applied in 1923–8, with a gold or bronze variant appearing in the latter part of that period. It is common to attribute Gloria Lustre pieces to Susie Cooper, but the majority of them do not feature her already distinctive style.

Made in 1925, a red, purple, pink, blue and gold Gloria Lustre vase from Gray's Pottery, showing the influence of Gordon Forsyth.

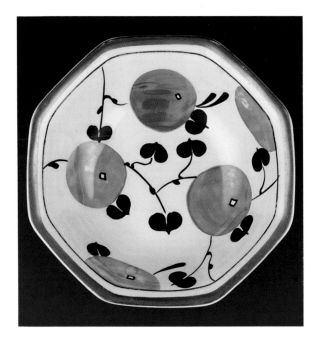

Gray's Gloria Lustre bowl in Oranges pattern from around 1927.

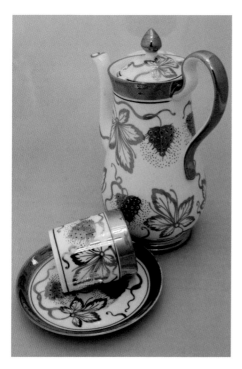

Above: Part of a 1927 Gray's Gloria Lustre silver coffee set in the Vine pattern.

Above right: Bold hand-painted Gray's pieces from around 1928, with enamel-like depictions of Iris and Tulips.

Lustre was never to become a major element of Susie's post-Gray's output, although she did carry forward a large number of banded and floral styles of decoration, perfecting them at her own factory, and generally improving on the methods used at Hanley. The techniques learnt at Gray's proved valuable in developing her highly individual style. Aerographing (spray painting), sgraffito (scraping off paint to reveal the surface below) and shaded banding (applying the brush at varying pressures) were all techniques used at Gray's and taken a stage further when Susie went solo.

Harking back to her childhood drawings on the farm and the courses taken at Burslem, the freehand painting of flowers was a staple technique for Susie and subsequent Gray's designers and decorators. Hundreds of floral patterns emerged from the factory when Susie was in charge of design, and for many years after she had left. These types of decoration were used extensively at Susie's own pottery, but were eventually to be replaced by transfer-printed versions.

At Gray's very few of the patterns were named by the factory. Given the vast number of variations, it would have been time-consuming and challenging to give a name to each. Occasionally, however, a pattern was identified by a mark to the base, such as Almond Blossom.

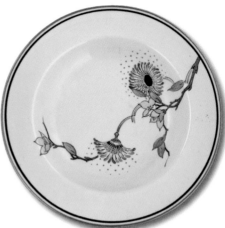

It was clear that Gray's was never going to allow Susie the chance to fulfil her potential as a designer of forms as well as of decoration. Gray was content with the bought-in undecorated wares and had no plans to begin pot production himself. This led to frustration on Susie's part and to her eventual departure. It had become apparent to Susie that shape and pattern should be considered together in order to produce the optimum combination. Now committed to a future in the Potteries, Susie left Gray's and struck out on her own.

Golden Catkin (above left), a Gray's print and enamel bowl from 1928. At Gray's very few of the patterns were named by the factory. Occasionally, however, a pattern will be identified by a mark to the base, such as the 1928 Almond Blossom bowl shown above right.

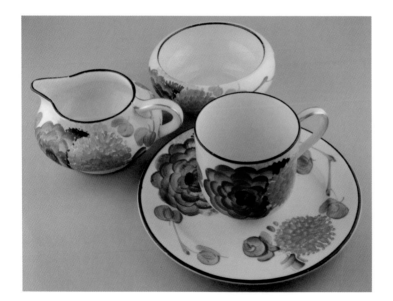

An early version of the Bronze Chrysanthemum pattern for Gray's. A variation of the design appeared after Susie Cooper had left the factory.

19

HER OWN BUSINESS

The initial output of Susie's Chelsea Works pottery was commercial tableware and bore similarities to some of the Gray's designs she had created during the previous decade. Both candle holders are from c. 1930, while the floral pot dates from early 1931.

T HE MOVE taken by Susie Cooper in 1929 to abandon a successful career at the well-established and innovative Gray's Pottery was greeted with dismay by her mentor, Gordon Forsyth, and by her employer, Edward Gray. Both thought she would make an early return, when her own efforts had failed. Both men underestimated Susie's determination and business acumen.

Her father, who had died in 1913, would no doubt have encouraged her desire to start up a business. Using the sum of £4,000 provided by her family, and with her brother-in-law Albert 'Jack' Beeson as a partner, in October 1929 she moved with six paintresses into rented rooms at the George Street Pottery in Tunstall. Within weeks, the creditors of the George Street Pottery took fright at the Wall Street Crash and forced her landlord into bankruptcy, but Susie simply found a new location. There was plenty of factory space around – and numerous white-ware suppliers keen to sell their output to a new designer.

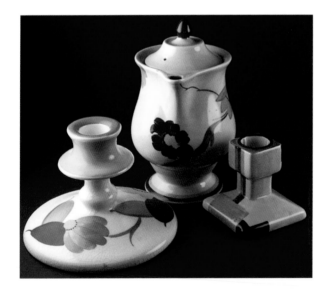

In early 1930 she rehoused her operation at the disused Doulton-owned Chelsea Works in Burslem, renting space from Gibson & Sons, and buying in undecorated pots from local manufacturers such as Grimwades, W. H. Grindley and Wood & Sons. The last, headed by the forward-thinking Harry Francis Wood, was to become more than just a supplier of plain pots and would later join forces with Susie in the creation of important new designs.

The initial output of Susie's Chelsea Works pottery was commercial tableware, which bore similarities to some of the Gray's designs she had created during the previous decade. Susie was still buying in undecorated hollow and flat ware, then creating her own patterns and motifs. For a short while, this was dominated by floral, geometric and banded themes. A crude Triangle backstamp was applied to Susie's pieces during this period, with the original factory marks often blanked out. There continues to be strong demand for Chelsea pieces, which were produced in relatively small quantities over just a few months.

The crude Triangle backstamp was applied to Susie Cooper's pots during the Chelsea Works period.

Her first commission at Chelsea Works came from the Nottingham department store Griffin & Spalding. During the Stoke-on-Trent Historical Pageant in May 1930, she was visited by one of the store's representatives, seeking locally produced ceramics of a particularly high standard. Other early orders came from Grants of Croydon and Dunn's of Bromley.

While the Leaping Deer image was to become her trademark in later years, the original design of a cavorting antelope-like animal was used as early as April 1930 for an advertisement for the Chelsea Works pottery in the *Pottery Gazette and Glass Trade Review*.

In February 1931 Chelsea Works took a stand at the BIF in London, sharing the new Olympia Hall with many bigger and wealthier exhibitors. In spite of her limited range of new designs and reworked Wood's shapes, the level of interest in Susie's stand caught the eye of Harry Wood, chairman of Wood & Sons.

As demand for Susie's creations had begun to rise and the small Burslem premises could not cope, Wood realised that a long-term relationship with the promising designer could only improve his sixty-year-old pottery business. In 1931 the firm offered Susie space at one end of its site in Newcastle Street, Burslem. More importantly, it also agreed to make shapes in earthenware to her specifications. This provided the foundation upon which the next phase of her career was built.

A Chelsea Works Fritillary pattern side dish from 1930.

THE LEAPING DEER

IN AUGUST 1931 Susie Cooper moved her business to the Wood's-owned Crown Works premises, where it was to remain for almost fifty years. Her original team of now experienced paintresses was augmented by a fresh intake from Burslem School of Art, all trained to prepare and apply paint to Susie's exacting standards. She believed, throughout her career, that she had a duty to create employment for local people, providing training in ceramics production and paying the best wages she could afford.

With a new home, the pottery also needed new branding to replace the primitive rubber-stamped triangle. Perhaps her most enduring design, the iconic Leaping Deer logo was applied by transfer to most of the earthenware output well into the 1950s. It is an excellent example of Susie's love of nature being blended with her precise draughtsmanship. Now in new premises, with an enthusiastic designer and team, as well as a supplier happy to deliver new shapes, Susie was ready for the next big step. The Leaping Deer was up and running, and the Kestrel was ready to take flight.

With his enthusiasm for Susie's talents, Harry Wood placed his team of skilled ceramic modellers at her command, relishing the challenge of new shapes after years of rather conservative Wood & Sons designs. Wood later gave her unrestricted access to his print shop, thus allowing for the development of her revolutionary transfer-printed domestic wares. Prior to this, however, she was happy to adapt existing Wood's shapes, such as tankards and the Rex range of tea wares, to show off her decoration. She introduced subtle changes to the existing hollow wares, streamlining the finished product.

As a pottery producer, Crown Works was already ahead of its competitors in terms of ceramics technology, using more advanced kilns than many rivals, which provided a more consistent product in larger volumes and at lower cost. Susie was later to formalise her relationship with the white-ware supplier through a combination of the two companies, which worked to the advantage of both parties. She was also able to deliver a high-quality product at an affordable price, which earned the loyalty of her customers.

Opposite:
After the move to Crown Works, as well as new tableware designs, Susie Cooper produced some larger ornamental items, using the technique of incising patterns into the clay before firing, creating nature-themed designs.

During the early days at Crown Works, Susie Cooper was happy to adapt existing shapes from partner company Wood & Sons, such as tankards.

During the later months of 1931 she worked the modellers and decorators hard as they sweated over Christmas orders and began preparing the exhibits for the following February's BIF at the Olympia Hall in London. Susie herself often donned her painter's apron in order to help meet the tight deadlines she had imposed on her team. The extra effort was essential, as the 1932 fair would be of critical importance to Susie's career and the pottery's lasting success.

The seventeenth BIF was the biggest trade fair of its kind in the United Kingdom, with total stand frontage covering 16 miles and floor space exceeding 30 acres. Patronised by Queen Mary, the Prince of Wales and the

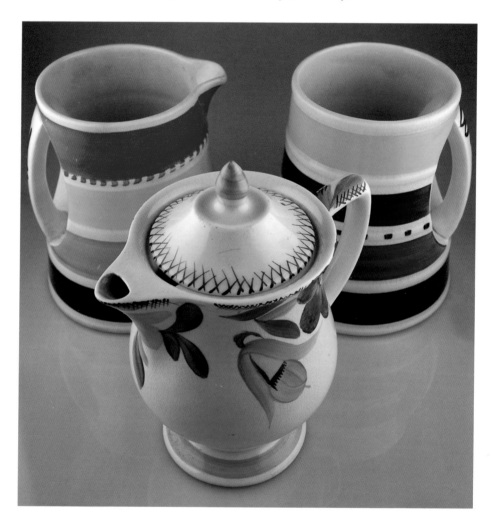

Duchess of York, the fair was an important showcase of British trade and industry. Rival ceramics designer Clarice Cliff was also present at the exhibition, as was Susie's former employer, Gray's Pottery. Potential buyers of British goods flocked to the show, including many foreign visitors attracted through the overseas mailing of ten thousand show catalogues.

Susie was determined that the new Crown Works pottery would not go to the show unprepared, or rely on mere reworkings of old Wood's shapes. She designed the striking stand herself to inaugurate an impressive range of household ceramics. The brand-new Kestrel shape was the centrepiece, accompanied by stunning decorative pieces that captured the imagination of many visitors, including members of the British royal family.

The Rex shape of tea and coffee wares was being produced by Wood & Sons at Crown Works. Susie Cooper streamlined and improved the design, as well as adding her own decoration.

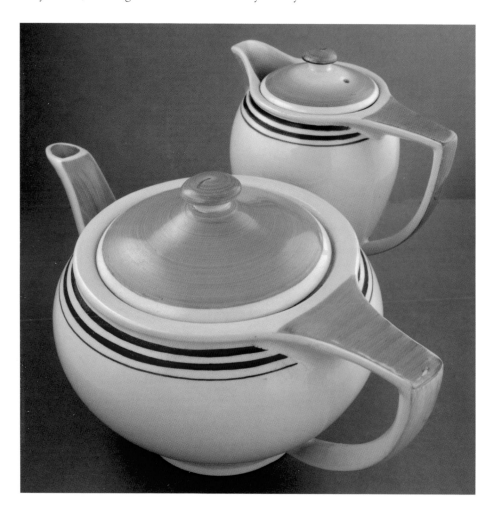

The Susie Cooper Productions stand benefited from Susie's earlier experience at the show, both with Gray's and in 1931 with Chelsea Works. She already knew how to boost the visual impact of her goods. Dressing the stand took almost as much effort as decorating the pots. Susie and her team delivered a memorable and effective display, considered bold and imaginative by visitors, the trade and the media.

According to reports of the time, folding doors in black and green were used to frame the entrance to the stand, revealing a formal dining-table set with a Susie Cooper dinner service. Arranged around the table were other designs on the new Kestrel and older Wood's shapes. Decorating one main wall was an oak panel painted by Susie herself with a biblical scene showing a man leading two donkeys.

Queen Mary made the first of many Susie Cooper purchases at the 1932 BIF. It is stated that she bought a breakfast-in-bed set decorated with the Briar Rose hand-painted floral pattern. Such a set comprised typically a teacup and saucer, small plate, teapot, sugar bowl and milk jug, covered muffin dish, cruet set, toast rack, eggcup, marmalade pot and butter pat.

At the 1932 fair Susie unveiled new patterns that included the highly stylised Woodpecker motif on a Kestrel-shaped tea service and lemonade set (comprising jug and six beakers), displayed alongside modern floral designs such as Briar Rose and an early hand-painted version of the floral Nosegay design. All of these pieces were marked with the new Leaping Deer backstamp and carried the legend 'A Susie Cooper Production'.

Instead of basking in the success of the fair, or focusing solely on her new tableware designs, Susie returned to Crown Works and began modelling some larger ornamental items with the help of the Wood's experienced potters, using traditional hand-throwing techniques rather than the usual

At the 1932 British Industries Fair, Susie unveiled new patterns, including the highly stylised Woodpecker motif, hand-painted here on a divided vegetable-serving dish.

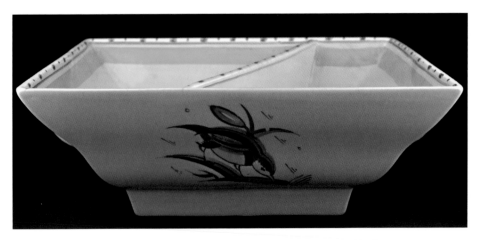

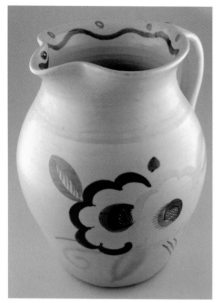

slip-casting. As well as hand-painting these decorative 'studio pottery' pieces, she invested time in perfecting the technique of incising patterns into the clay before firing, creating nature-themed designs such as squirrels, tulips, acorns, foxes, rams and antelopes.

Sometimes using cream glazes, or mottled pinks, mustard, blues and greens, these vases, jugs and bowls were an interesting diversion, and proved to be successful. Demand was high and the incising process too slow, so moulds were made for a range of slip-cast pieces, with the outlines finished by hand. This makes it difficult to distinguish between the entirely hand-made and the later mass-produced pots.

Top left: Hand-painted, hand-thrown studio jug from around 1932.

Top right: Incised studio-ware jug with oak-leaf and acorn decoration, c. 1932.

Left: Ribbed 1932 studio-ware vase, creating a tube-lined effect.

27

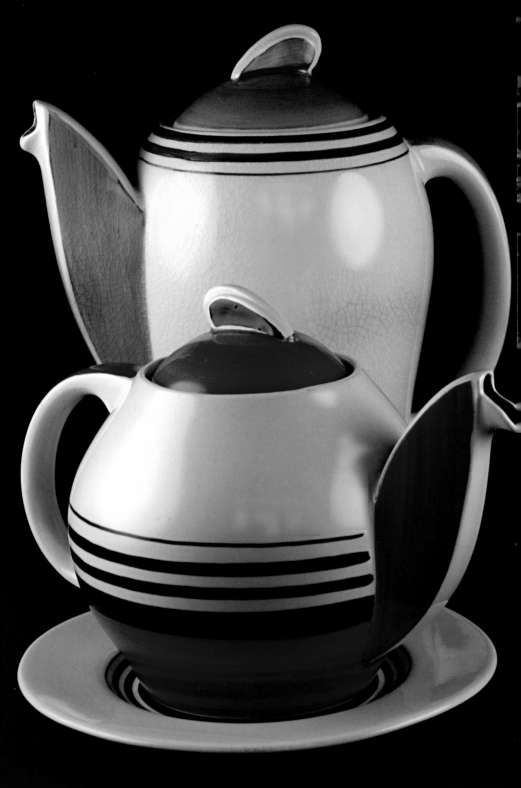

THE KESTREL YEARS

KESTREL was the first significant outcome of Susie's association with ceramic modellers at Wood & Sons. The highly original shape was the result of her desire to produce a form that was functional and attractive in its own right, even without decoration. Plenty of tea and coffee sets were produced with a simple cream-glazed exterior and coloured interior. Kestrel was also well suited to a broad range of body colours, patterns and styles of decoration.

The shapes lent themselves to being produced in many sizes, so that Susie's pottery could offer everything from bachelor (one-place setting) to family-size sets. Tea, coffee and hot-water pots were equally striking. Knops and handles carried the design theme throughout the range. Of equal importance, the pots were easy to handle and clean, were stable when standing, and could be poured without dripping.

One of the most successful forms is the full-size coffee pot, which still looks fresh and modern today. Standing 19–20 cm tall, including the 'cresting wave' knop, the pot measures a similar length from the tip of the spout to the outside curve of the handle. The spout sweeps gracefully up from where it emerges, and the body shape tapers outwards to bulge to a circumference of more than 30 cm. The shape should appear top-heavy, but is both sturdy and elegant. The broad curves of the bulbous upper body are also perfect for decoration.

Full-size Kestrel teapots look reassuringly stable and robust. Measuring around 16 cm in height, they are wider than they are tall, at 22–23 cm from handle to spout. Almost globular in shape, the curve of the lid and the same crested knop make the pots look highly streamlined. The circumference is typically around 45 cm, providing a big area for Susie's paintresses to decorate. The Kestrel teapot could be scaled down in size to great effect. The two-cup variants (12 cm high) proved very popular in bachelor sets and tea-for-two services. They could carry the same types of decoration without compromising the design concept.

Susie's hot-water pots, often supplied to complement tea services, mimic the Kestrel coffee-pot shape, but without the protruding spout. The large

Opposite:
The Graduated Black Bands range in bold colours such as orange (Tango) has become highly prized by collectors, as a result of television productions such as *Agatha Christie's Poirot*.

version, generally married to a six- to eight-place teaset, stands 18 cm in height and is slightly narrower in circumference. Collectors should note that these are often sold as coffee pots to the uninitiated by the ignorant or hopeful. A smaller version of the water pot was produced for breakfast-in-bed sets, etc.

Cream and milk jugs shared some of the family characteristics, in terms of their slightly bulbous bodies, and the style of their spouts and handles. Sizes varied for cream and milk, or for smaller and larger services. Sugar bowls also varied in size, but the version with two handles and the Kestrel knop on its cover is particularly attractive, and hard to find.

Susie was very careful to build flexibility into her designs, in order to make best use of stock shapes as well as the new forms. Kestrel coffee sets, for example, could come with three known variants of cup. Most collectable these days are the straight-sided can shapes. Susie's later coffee can in china was to become an industry standard, adopted by most factories and popular to this day. However, many Kestrel coffee sets featured either the curving,

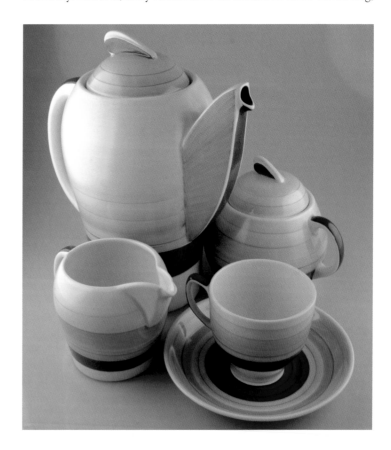

Kestrel was the first significant outcome of Susie's association with ceramic modellers at Wood & Sons. The shape was the result of her desire to produce a form that was functional and attractive in its own right.

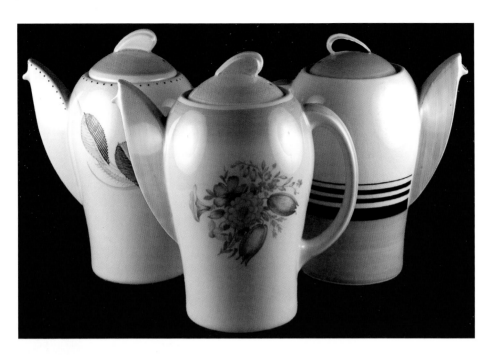

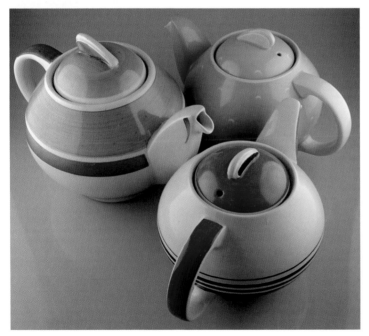

One of the most successful Kestrel forms is the full-size coffee pot, standing 19–20 cm tall, including the 'cresting wave' knop.

Full-size Kestrel teapots look reassuringly stable and robust and are almost globular in shape. The curve of the lid and the crested knop make the pots look highly streamlined.

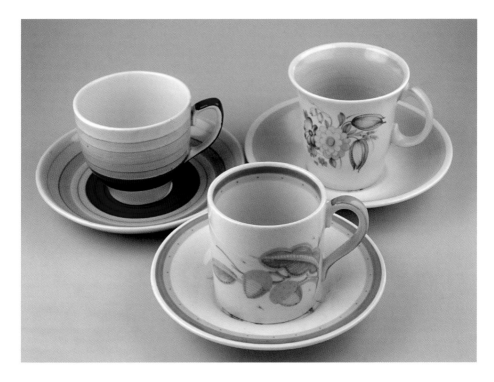

Kestrel coffee sets could come with three known variants of cup. Most collectable are the straight-sided can shapes. However, many sets featured either the curving demitasse, more like an eggcup in shape, or a taller, tapering form with flared rim.

more eggcup-shaped demitasse, or the taller, tapering form with the flared rim. Both are equally commonplace and appealing, and sit just as comfortably with the coffee pots, jugs and bowls.

Susie's teacups for use with her Kestrel sets are perhaps more generic in appearance. The broad, relatively shallow bowls draw their sole Kestrel family resemblance from the modelling of their handles. Teasets were generally completed with the appropriate size of water pot, sandwich plates and, for larger sets, a slop basin.

Having created a striking and successful range of shapes for the major tableware components, Susie had no need to spend time redesigning flatware, and so was able to continue using standard Wood & Sons plates, saucers and bowls decorated with her popular patterns. This enabled the factory to step up production.

By 1932 Susie Cooper Productions was employing fifty-eight people, mostly engaged in decorating the expanding range of tableware and new studio items. The increased popularity of the factory's output necessitated higher volumes and placed greater demands on the decorating personnel. Susie began to examine her techniques in order to achieve greater efficiency without compromising style and quality.

The end of large-scale hand-painting was approaching and the era of banding had begun, allowing Susie Cooper to make her mark on contemporary tableware design. Banding was still a hand-painted finish, but it was easy to apply effectively, making it suitable for use by inexperienced decorators. On joining, trainees would first be assigned to the 'lining' desk and, for their benefit, the popular Graduated Black Bands series was created. The Graduated Black Bands range in bold colours such as orange (Tango) has become highly prized by collectors as a result of television productions such as *Agatha Christie's Poirot*. It is ironic that a form of decoration created for trainees should now command particularly high prices. When the bold solid colours (red, yellow, orange, green and blue) were combined with varying-width black bands on the tall coffee pots and globular teapots of the Kestrel form, a 1930s design icon was established.

As the 1930s progressed and public demand for bold colours and strident patterns began to wane, Susie turned her attention to more subtle forms of decoration. This resulted in a series of hugely successful wash-banded ceramics. A sequence of softer colours in concentric rings was applied. The resultant design was particularly popular as a gift for newlyweds, becoming known as Wedding Ring. From the early 1930s until the 1960s these banded designs in a variety of pastel colours became a mainstay of the company, bringing in huge orders from retailers at home and abroad, which helped finance Susie Cooper Productions for many years.

Susie had developed techniques of thinning the colours with turpentine so the banding could be applied more smoothly and with greater translucence. The brush strokes could be varied so that darker and lighter shades could be applied within each band. She believed that the skills of her team (now including forty paintresses) in applying the wash and shaded bands were unrivalled in the pottery industry.

The horizontal bands of varying shade and colour, mixing soft browns, blues and greys, seemed to suit the times, and the combination of Wedding Ring and Kestrel caught the attention of the china and glass buyer for John Lewis, Mrs Elvie Macdermott. The workforce-owned department-store group ordered two versions to bear the John Lewis and Peter Jones names.

Susie later explained that tea and dinner wares were sold by John Lewis as individual pieces, so that customers could build up their sets gradually. This was good for the factory, because it knew that the design would be kept in stock for some time, with repeat orders. The department-store chain's shops were the perfect outlets, as Susie Cooper appealed greatly to the middle classes because of her commitment to high quality and affordable prices.

In spite of the early success of new patterns on Kestrel, innovation was to remain a key part of the Susie Cooper approach. At the 1933 BIF she launched the striking and well-received Kestrel vegetable-tureen design.

In 1933 Susie
Cooper launched
the Kestrel
vegetable-tureen
design (shown
here in Crayon
Line). Patented
in March 1933,
the dish features
a curved lid with
flattened top
that can function
either as a second
serving receptacle
or can be inverted
to fit exactly
inside the base
for stacking
and storage.

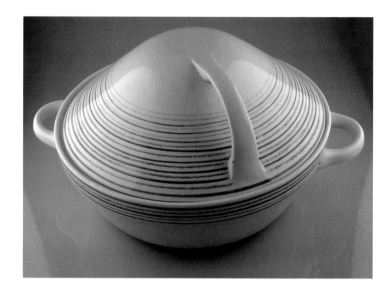

Patented in March 1933, the 26-cm-wide dish features a highly individual curved lid with flattened top that can function either as a second serving receptacle or can be inverted to fit exactly inside the base for stacking and

A smaller version
of the Kestrel
tureen was
created. The sauce
tureen had similar
attributes to the
larger version but
came equipped
with a ceramic
ladle. This is a
matt-glazed
Crayon Line
version.

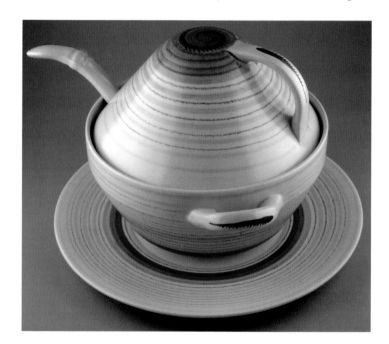

storage. A smaller version was created, the Kestrel sauce tureen (19 cm wide), having similar attributes to its bigger counterpart, but coming equipped with a charming ceramic ladle.

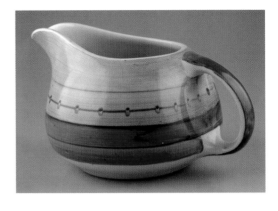

Banding, painted dots and, later, transfer-printed decoration were happily accommodated on the tureen, with its spacious surfaces for a wide range of patterns and colours. The dishes could be bought to match existing dinner services, as well as being offered in Wedding Ring and other new looks.

Another shape of tableware was created for launch at the 1933 fair. Lower and squatter in shape than Kestrel, with dropped handles, it was known as Curlew, continuing the bird theme. The design was less versatile

Another shape of tableware was created for launch at the 1933 British Industries Fair. Lower and squatter in shape than Kestrel, with dropped handles, it was known as Curlew. Shown here is a cream jug.

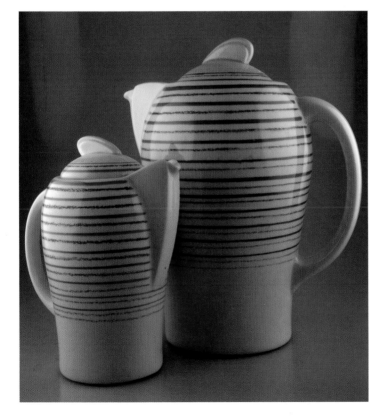

Following the success of Wedding Ring, the decorating team moved to narrower horizontal decoration in autumnal colours known collectively as Crayon Line, shown here on two sizes of hot-water pot.

Another family of popular patterns was known as Polka Dot. It was to be a lasting success, with versions still appearing on Susie Cooper's bone-china designs three decades later.

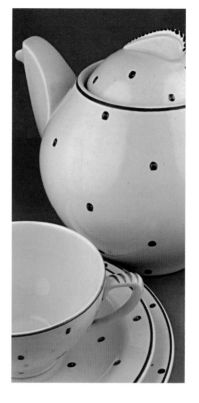

than Kestrel and failed to catch on in the same way, even though the vegetable dishes produced in the Curlew range were undeniably striking.

Meanwhile, Wedding Ring had inspired a host of imitators, so Susie felt the need to modify and evolve her decorating approach. From designs banded with broad brushstrokes, the team moved to narrower horizontal decoration in autumnal colours, known collectively as Crayon Line. There were fancier variations such as Crayon Loop, and matt finishes appeared to accompany the usual high-gloss glazes. Cheaper and quicker than the tube-lining process being used elsewhere in the Potteries, the technique provided a similar visual effect.

Another family of popular patterns was known as Polka Dot. Again, trainee paintresses could be taught the technique with ease. They learnt to space decoration accurately, apply the paint consistently and cover each surface thoroughly. Susie explained that the pattern enabled her junior decorators to grind and handle the major colours. As soon as she was happy with their proficiency in applying the dots, the pieces could head to the kilns for firing, rather than being wiped clean to be reused.

Polka Dot was available through John Lewis and Peter Jones. These stores bought even the 'seconds' with minor flaws, which were stamped with a plain 'John Lewis' or 'Peter Jones'.

Polka Dot was available through John Lewis and Peter Jones. Indeed, the retailer was so smitten with the pattern that its stores bought even the 'seconds' with minor flaws, which were stamped either with plain 'John Lewis' or 'Peter Jones', or were sold with no backstamp at all. Polka Dot was to be another lasting triumph, with versions still appearing on Susie's bone-china designs three decades later.

As the factory's output grew in volume, many more junior paintresses were being used, and the more experienced workers were either occupied with the more complex designs, or helping with training. Far from being frustrated by the situation, Susie relished the challenge of creating new patterns that could be produced by her workforce. In many ways, this reduced

the risk of over-complicating her designs, potentially increasing the costs and alienating a public happy to invest in plainer but still pleasing decoration.

Susie was equally clever at adapting older designs by the simple introduction of dots within shaded bands, modifying spots into dashes, commas, crosses or even stars. Combinations of these different basic techniques added to the product range without stretching her decorators beyond the limit of their abilities.

Older designs could be adapted by the simple introduction of dots within shaded bands, modifying spots into dashes, commas, crosses or even stars.

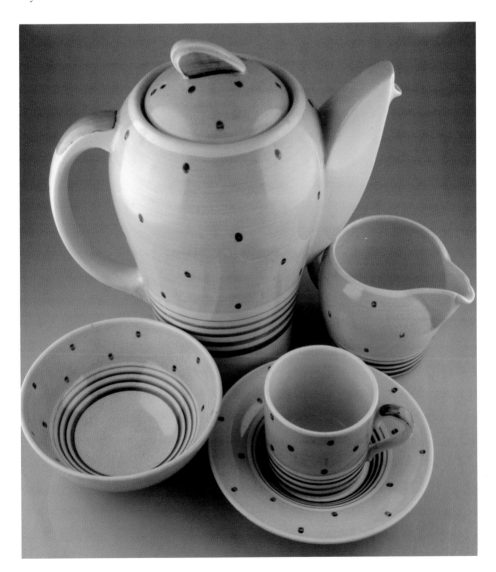

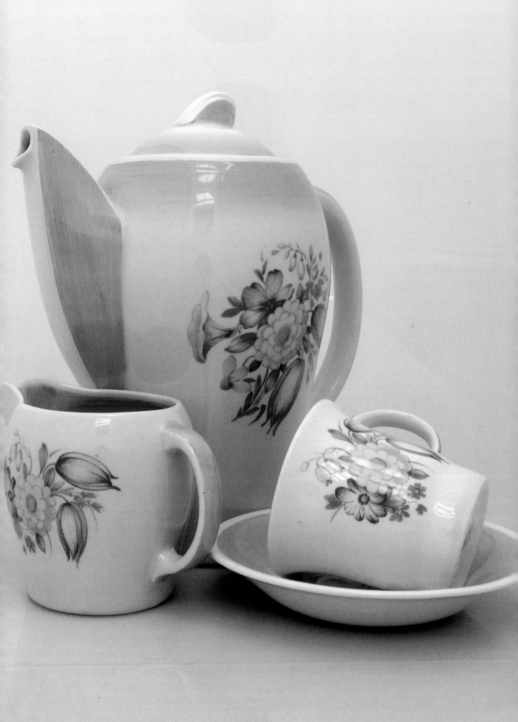

PRESSED INTO PRINTING

MASS-PRODUCTION was the way ahead for Susie Cooper Productions, given soaring demand within the United Kingdom and overseas. The growing workforce, with a large untrained element, needed designs that could be produced quickly, cheaply and consistently. Susie wanted to maintain a base of hand-painting, but also to find a way of boosting output. This involved making use of the Wood's print shop for her own transfer-printed outlines. These allowed her to design and apply centre motifs of pretty and complex floral sprays that would come to epitomise her mid-1930s output. Susie invested considerable time and talent in the creation of her own highly detailed artwork, producing her own colour separations and using manufacturers who were able to meet her exacting requirements.

Transfer printing is dismissed by too many ceramics experts as being a form of cheating. In particular, there is a tendency to dismiss the Susie Cooper transfer-printed wares as 'too common' and 'easy to make', but at the time of their introduction many other factories were convinced that the patterns were still hand-painted, such was the quality of the design and the expertise of the application.

The likes of Dresden, Swansea Spray and Printemps represent highly sophisticated examples of graphic art, applied with great skill, and often accompanied by hand-finishing of the highest quality. These lithographic sheets were very expensive to make, and large runs had to be ordered to make them economical. They were to raise the bar for the British pottery industry as a whole.

One clear difference in Susie's use of lithographic sheets was that she designed all of her motifs so as to fit the different sizes of wares, rather than simply placing them anywhere on any pot, which was what other manufacturers of transfer-printed domestic wares so often did. Adding a final touch, Susie placed smaller motifs, such as single buds or feathers, on the opposite side of a cup, or even on the inside. Customers and competitors greatly admired this attention to detail.

Opposite:
Susie Cooper used the Wood's print shop for her own transfer-printed outlines. These allowed her to design and apply centre motifs of pretty and complex floral sprays that came to epitomise her mid-1930s output. Shown here is Swansea Spray.

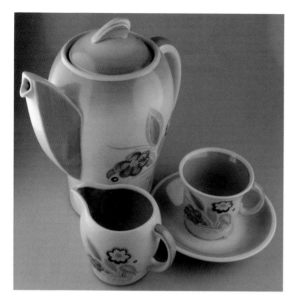

A popular early hand-painted design called Nosegay re-emerged as one of the first transfer-printed motifs. For a while, any additional banding or shading was added by hand. Eventually, however, even the blocking of colours could be achieved by print. The transfer-printed designs on Kestrel were launched at the 1935 BIF, with the same technique also being applied to the more traditional and well-established Rex shapes.

One of the most famous Susie Cooper patterns, Dresden Spray (later known simply as Dresden), might never have made it on to the Kestrel or Rex shapes. It was offered initially to Wood & Sons, which had

A popular early hand-painted design called Nosegay re-emerged as one of the earliest transfer-printed motifs. For a while, any additional banding or shading was added by hand. Eventually, however, even the blocking of colours could be achieved by print.

In pink and blue/green variants, Dresden was to become a huge success and, on Kestrel, perhaps Susie Cooper's best-known design. It remained a bestseller for more than twenty-five years.

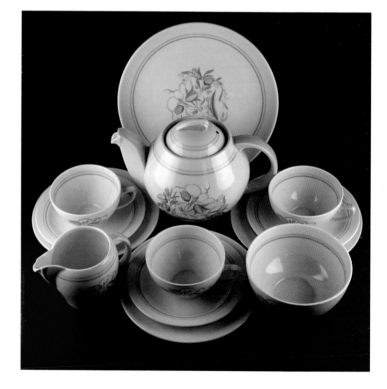

decided to market some of its own earthenware with Susie's decoration. She had therefore created a range of stylised patterns for the partner company, and modified some of its shapes. Her next step was to design a new transfer-printed motif for Wood's, to be applied to the centre of the factory's range of square plates. She came up with Dresden.

Based on a traditional Staffordshire posy pattern, Dresden was a pretty and elaborate design, but Harry Wood thought it potentially beyond the capabilities of Wood's own print shop, as well as too big a departure from his firm's conservative domestic-ware designs. Convinced that the complex floral pattern was a winner, Susie agreed to pay the development costs and to bring the pattern (made successfully at Wood's) back to her own operation, and began applying it to Kestrel and to Rex shapes. The name comes from a small southern district of Stoke-on-Trent, and not from the German city.

In pink and blue/green variants, Dresden was to become a huge success and, arguably, on Kestrel, Susie Cooper's best-known design. It took pride of place at the following year's BIF in London and remained a bestseller for more than twenty-five years, rivalled only by Wedding Ring in popularity and longevity. Again John Lewis was a keen supporter, selling both colours in large volumes, as well as Dresden-decorated table linen. Peter Jones of Sloane Square sold a dinner service in pink Dresden to Edward VIII for Mrs Simpson in 1936.

The April pattern, introduced in 1936, features a pretty transfer-printed motif and carried the pattern name with the Leaping Deer backstamp.

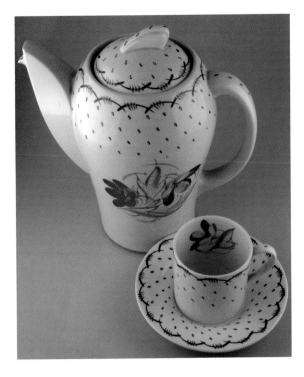

Swansea Spray, following a similar design theme to Dresden, caught the eye of buyers at Harrods in Knightsbridge. It joined a family of floral transfer-printed designs of the mid- to late-1930s, including Printemps, April, Grey Leaf and Cactus. Numerous colour variations exist of each pattern, along with combinations of hand-painted bands, block-printed shading or additional decoration around the central motif. The factory again had to expand, hiring more decorators who were trained in the art of applying the fragile transfers to the under-glazed pots.

Kestrel coffee pot in transfer-printed Two-leaf Spray pattern from the mid-1930s.

Cactus, a floral transfer-printed pattern from around 1937, applied to a side plate.

A version of Susie Cooper's Leaping Deer trademark was created as a lithographic image and applied to Kestrel and Rex pots and flatware.

It would be wrong to think that transfer printing was limited to flowers. A version of Susie Cooper's trademark Leaping Deer was created as a lithographic image and applied to Kestrel and Rex pots and flatware, replacing an earlier and costlier hand-finished version. Also printed rather than painted were items of nursery ware with motifs such as Cowboy, Noah's Ark and a variety of farmyard animals. These cartoon-style forms of decoration later appeared on breakfast sets, etc, for adults, sporting the Golfer, Horse and Jockey or Skier designs.

Throughout the second half of the 1930s the emphasis remained on transfer printing, with international markets opening up and factory output remaining at a high level. The greatly admired Acorn pattern, which was both simpler and yet more striking than Dresden because of its combination of colours, was unveiled at the 1937 BIF. The use of double-colour banding dominated by turquoise catches the eye, while the central motif uses pink, grey, gold and more turquoise. Patricia Rose, another of Susie's well-loved creations, made its first appearance in 1938, starting with an ostensibly simple pink rose design and expanding to include several colour variants and featuring various forms of scrolling and other border decoration. The near-photographic quality of the rose motif had taken the transfer-printing process to a new artistic peak.

Far removed from the transfer-printing process was aerograph painting of ceramics, which was another technique embraced by Crown Works. It was quick to apply, based largely on spray-painting of pottery shapes, and could result in some striking effects.

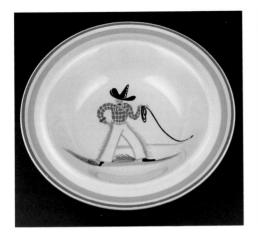
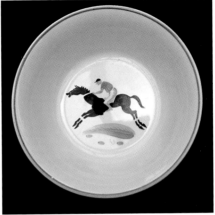

Above left:
Printed rather
than painted were
items of nursery
ware with motifs
such as Cowboy,
shown here on a
cereal bowl from
around 1936.

Above:
Cartoon-style
forms of
decoration
appeared on
adult-oriented
breakfast sets, etc,
featuring designs
such as Horse &
Jockey.

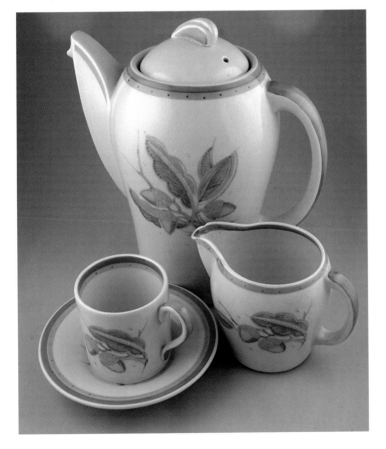

Left: Acorn, which
was to become
one of Susie's most
popular patterns,
was unveiled at
the 1937 British
Industries Fair.

43

Aerograph painting of ceramics was a technique embraced by Susie Cooper. It was based largely on spray-painting of pottery shapes. The colour palette included pinks, deep reds and browns, bright blues, yellow and varying shades of green. Shown here is the Crescent pattern on red.

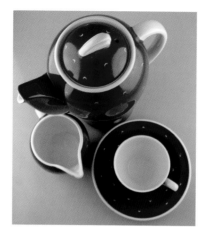

Having discovered a new spray gun that could coat larger areas with a uniform finish, Susie was quick to spot the potential for volume production of pots in vivid hues.

The factory's colour palette blossomed to include pinks, deep reds and browns, bright blues, yellow and varying shades of green. The aerographed base colours were generally decorated using the 'sgraffito' method of scraping away lines, dots and areas to reveal the white surface beneath. In effect, the approach was almost the opposite to Polka Dot, but with small hand-'unpainted' crescents, spots, swirls and diamonds revealed beneath the sprayed background colour.

The new Falcon range of tableware shapes, as well as the existing Rex and Kestrel families, was to benefit from the aerographed form of decoration. While less immediately striking as a shape, Falcon had a pleasing look that perhaps suited the more conservative household. The looped knop to the lids of tea and coffee pots was a nice touch, often enhanced with a little gilt. Cups featured a 'cane'-style handle and, as with Kestrel, there was plenty of room to accommodate Susie's diverse range of patterns.

Coffee pots in the Crescent range of patterns, most often found on Kestrel, look equally striking in pink, deep red, pale blue or green. As

Right: Pink Crescent, shown here on a Kestrel coffee pot and cream jug, was one of the most popular colour options from 1938.

Opposite: The new Falcon shape of the late 1930s had a pleasing, if conservative, look. The looped knop to the lids of tea and coffee pots was a nice touch, often enhanced with gilt. Cups featured a 'cane'-style handle.

Susie's decorators became more skilled with the aerographing and sgraffito processes, they were able to undertake her more complex patterns of stylised feathers and fruits, some of which were shown at the BIF in 1938. When the Second World War cut the output of Britain's potteries, with labour, material and energy sources all in short supply, it was a major benefit for a factory to have plainer, simpler designs to fall back on.

In 1938 Susie married Cecil Barker, an architect. They made their home at The Parsonage, Dilhorne, just outside Stoke-on-Trent. In 1940 Susie received the Royal Society of Arts (RSA) 'Royal Designer for Industry' award, becoming the first woman to receive the recognition. It was also the first time that the award had been made solely for pottery design.

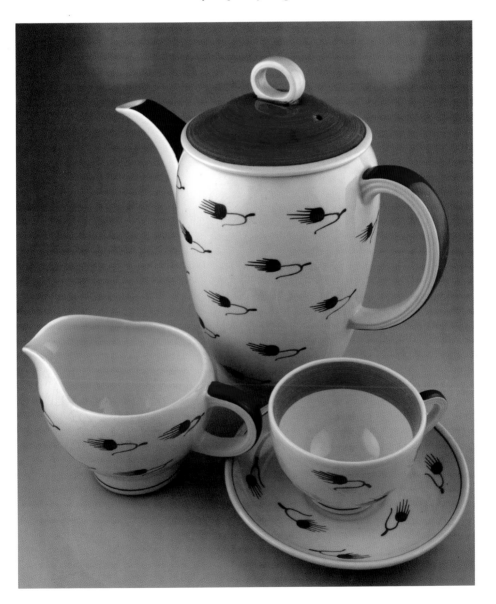

Part of a Blue Fern coffee set from around 1938, a striking colour in the Falcon shape.

A fire in the Wood's packaging house in May 1942 consumed a large part of Crown Works. Lost in the blaze were most of the lithograph stocks, which added pressure to find a quick alternative method of decoration while replacement prints could be made. Given the fire damage, the labour shortages and the impact of war on demand, Susie Cooper chose in the summer of 1942 to cease operations. In some ways, the glory days of Susie Cooper Productions had come to an end.

An early floral pattern used on Falcon, the Coraline design on a part coffee set from around 1938.

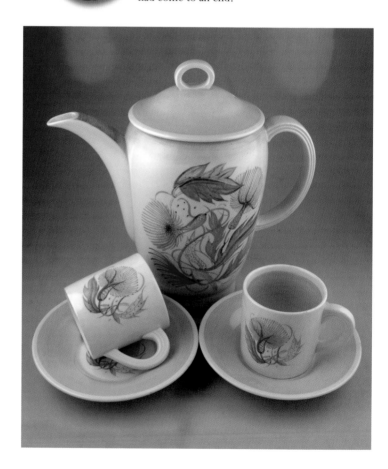

Opposite:
The Stars range on Falcon was a popular choice, featuring gilding to the handles and knops. This is a part coffee set in the green variant from 1939.

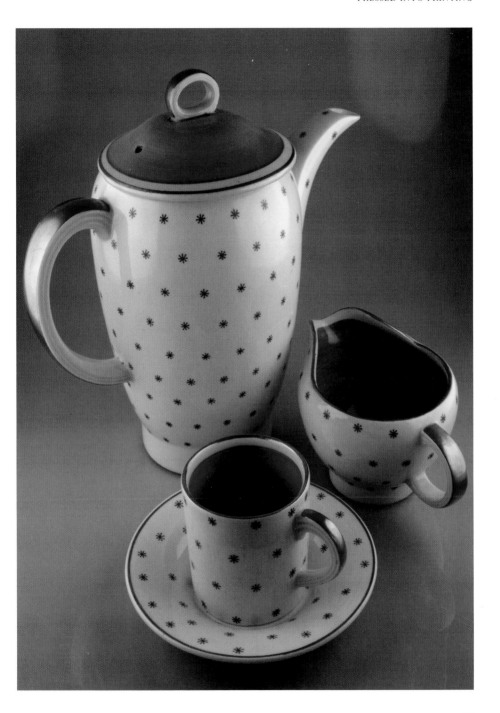

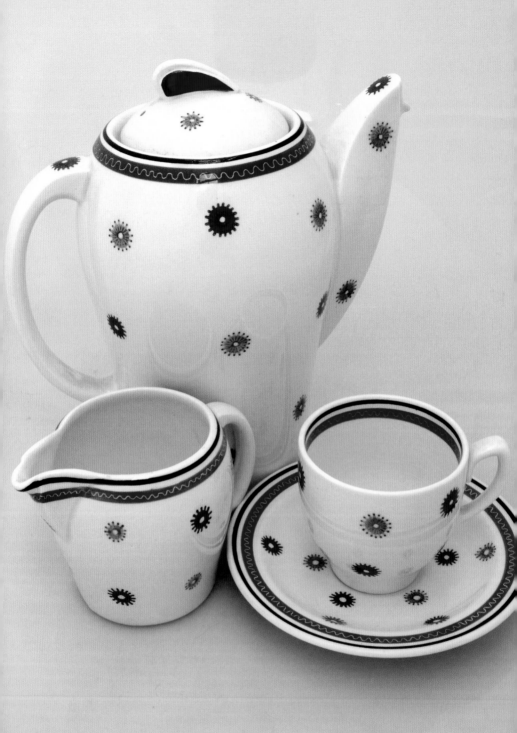

A NEW START

REBUILDING THE POTTERY following the fire and the wartime years of neglect proved to be a protracted affair. The process was hampered by post-war restrictions, shortages of men and materials, plus some unwelcome bureaucratic interference. In addition, the supply of white ware from Wood's was limited. A rival designer, Charlotte Rhead, had in 1942 formed a business relationship with Harry Wood that helped his factory through the war years, and she could therefore claim first call on Wood's post-war output.

The birth of Susie's son, Tim, in 1943 might also have played its part in dampening her enthusiasm for a rapid return to volume production and full-time design and pottery management. However, her initial reluctance to restart the business was overcome when her husband, Cecil, joined her in the pottery.

One result of the post-fire malaise was that the flow of new patterns had been choked off. In the first four post-war years, only two hundred designs were introduced, which represented less than a single year's creativity in the 1930s. While old favourites such as Patricia Rose continued to be reworked, much of the new product was based on aerographing and sgraffito. There was a brief revival of hand-painted patterns on earthenware, such as Ferndown, Blue Dahlia and Gooseberry, but, with soaring demand from her international customers, hand-painting quickly became uneconomical and impractical. However, Susie was quick to adopt the higher-quality cover-coat printing process, creating new patterns that worked readily on the new can-shaped coffee cups.

Rising demand from the United States in particular was both a challenge and a boost for the recovering business, with banded patterns on Kestrel being favoured by retailers for American post-war newlyweds. Back in Britain, a stand cobbled together for the 1947 BIF introduced Tree of Life, Starburst and Quatrefoil on Kestrel and on the Falcon shape. This was to be the last show until 1950.

In 1949, with lithographic prints again available for decoration, volumes began to pick up. Variations of Printemps, Tigerlily, Patricia Rose, Grey Leaf

Opposite:
A fire at Crown Works in 1942 convinced Susie Cooper to cease production until the war ended. The flow of patterns slowed after the war, because of labour and material shortages. The Starburst pattern was one of the few launched in 1947. Shown here is a later, export-oriented version on Kestrel.

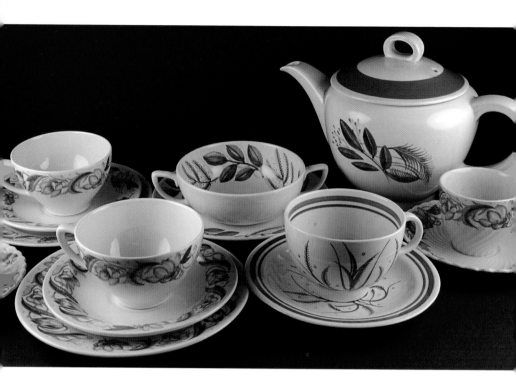

A Ferndown Falcon teapot from around 1959, Everlasting Life soup bowl (1952), Highland Grass teacup (from 1956) and the earlier Endon pattern on tea and coffee cups.

and Long Leaf emerged. Sgraffito and aerograph designs such as Ladybird, on its mahogany ground, were a return to form. However, Susie was still struggling with the quantity and quality of white ware. She began to look towards bone china for her future, which would bring this phase of the Susie Cooper story to a close.

It would be wrong to suggest that Susie Cooper was less popular, less creative or less successful in the 1950s and 1960s. While collectors tend to focus exclusively on the period 1922–40 as her 'golden age', much of the post-war output was of a very high quality and featured some striking new patterns and shapes. However, Susie's shift from the production of earthenware to manufacture from bone china is seen by many as a turning point.

Susie confronted the problem of inadequate white-ware supply by seeking out bone-china production. She had long harboured ambitions to make affordable decorative china and, with costs having fallen, she felt the time was right to tackle the new medium. Capital was raised and she bought a small china works in Longton. Her husband, Cecil, set to work transforming the operation, including expansion of the existing kilns, so that it could meet his wife's high standards. He is deemed to have been the driving force behind the china venture, helping Susie move quickly to the new material.

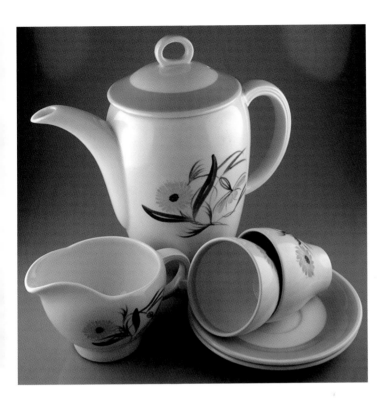

A Marigold part coffee set from 1959, on the Falcon shape.

Jason China emerged as a perfect Susie Cooper establishment, with a motivated and skilled workforce, improved working conditions, and the ability to supply a quality china product. The shapes emerging from the renamed Susie Cooper China went on to be decorated at the main plant in Burslem. For the first time, Susie was to have complete control over her product, from the raw clay to the completed crockery.

Rex-shaped coffee wares in the Blue Gentian pattern from 1959.

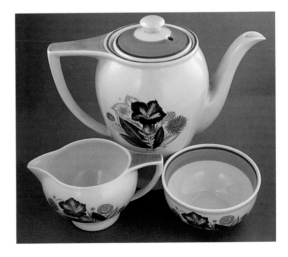

She remained keen on providing her domestic wares at affordable prices, using the new venture to keep manufacturing costs down so that her fresh designs, such as Hyde Park, with its modern and stylish leaf motif, could undercut rival products from major manufacturers such as Wedgwood.

The market and the industry greeted her initiative with enthusiasm. Susie Cooper designs were chosen for the Royal Pavilion at the Festival of Britain in 1951, and were also shown in other areas of the Festival displays. The RSA chose a Susie Cooper design for its own china, and the Royal Designers for Industry plate to celebrate the RSA's bicentenary was also designed by Susie.

While developing her new bone-china production, she introduced another classic shape, Quail, which made its debut at the Festival of Britain and continued the bird theme into the new era. Quail is another striking and highly successful organic form that was decorated with stylish but simple patterns such as Gardenia, Azalea, Magnolia, Wild Strawberry, Whispering Grass and Teazle. As ever, she focused on floral and plant motifs that showed off the elegant shapes.

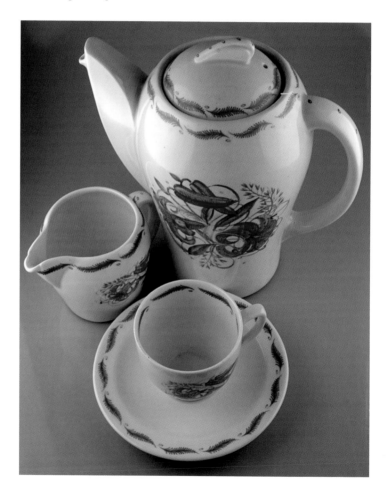

Variations of the transfer-printed Tigerlily design, shown here on Kestrel, emerged in the late 1940s and early 1950s to meet demand from North America.

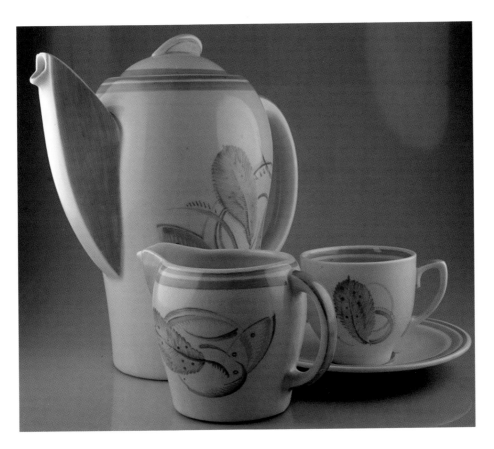

While the Grey Leaf pattern first appeared in the 1930s, this transfer-printed version on Kestrel coffee wares is from the post-war era, probably dating from 1950.

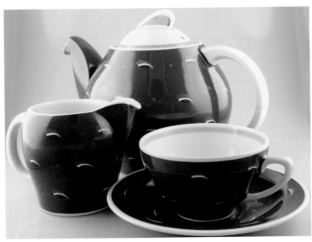

Sgraffito and aerograph designs such as Ladybird (1949), on its mahogany ground, were a return to form after the post-fire problems.

While developing her new bone-china production, Susie Cooper introduced another classic shape, Quail, which made its debut at the Festival of Britain. These two Quail teapots date from 1951.

Quail was another striking and highly successful organic form that was decorated with stylish but simple patterns such as Gardenia, Azalea, Magnolia, Wild Strawberry and Stars. As ever, Susie Cooper focused on floral and plant motifs that showed off the elegant shapes.

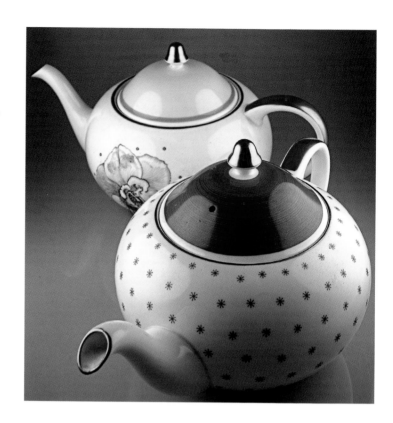

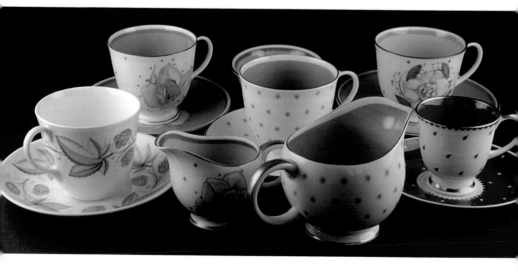

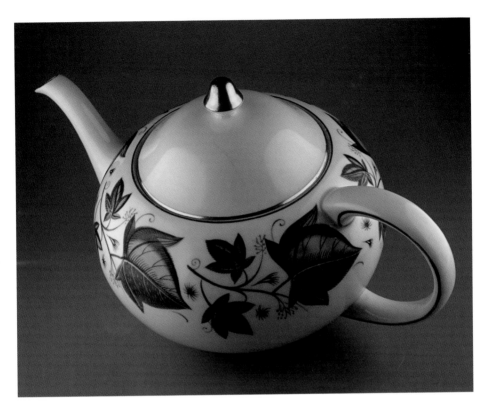

A striking Quail teapot design, featuring the Ivy pattern in blue.

One of her lasting contributions to tableware was her can shape, which emerged from the new china company in 1958. It was the first of the delicate and versatile cylindrical china forms that were to enter the market in the late 1950s and early 1960s, but was to become the 'default' design for many manufacturers over decades. The shape was a development of her earlier earthenware cylindrical cups, albeit bigger and better proportioned. It was to spawn other shapes in the Susie Cooper range, with jugs, sugar bowls, preserve jars and coffee pots based on the same design concept. Timeless patterns such as Black Fruit and Classic Vista were applied particularly effectively to the can shape, remaining in production for many years.

One of Susie Cooper's lasting contributions to tableware was her can shape, emerging in 1958. Timeless patterns such as Black Fruit, shown here, were applied effectively to the can shape, remaining in production for many years.

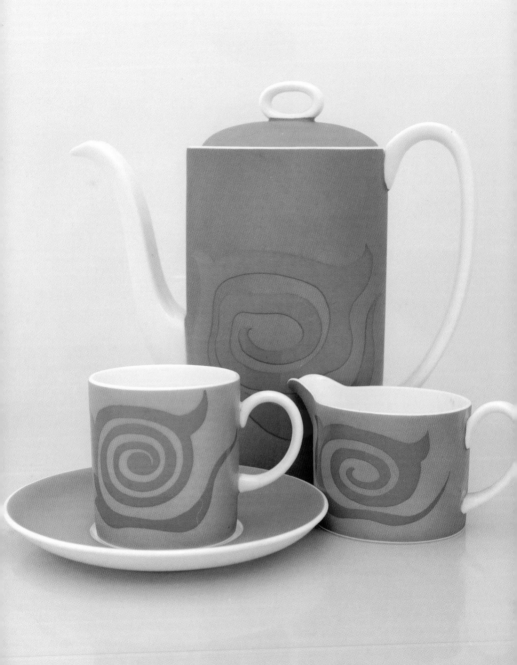

LATER YEARS

IN MARCH 1957 the Crown Works premises were badly damaged by fire. This was a major setback, as production was halted for almost a year. Valuable momentum was lost, so, when production resumed, Susie decided to augment her established tea and coffee china ranges with dinner ware. She struck a deal with R. H. & S. L. Plant in 1961. The firm, which marketed its own wares under the name Tuscan, had a bone-china biscuit oven that was not being used. This provided valuable additional capacity for the dinner-ware range. Around the same time, production of unfashionable earthenware was brought to an end. The merger with Plant led to the formation of the Susie Cooper-led Tuscan Holdings.

Susie Cooper had rejected various informal approaches to design for the giant Wedgwood group, an organisation she admired greatly but had no desire to work for. When, in 1966, Sir Arthur Bryan was appointed managing director of Wedgwood, he again sought to enlist Susie's talents. He succeeded through the acquisition of the Tuscan Holdings companies. It was not just Susie's talents as a designer and her valuable reputation that Wedgwood desired. Her skills as a factory manager, workforce motivator and commercial innovator all also appealed to Sir Arthur, and he was not prepared to take no for an answer.

The merger was intended to provide long-term security for the Tuscan workforce by diverting Wedgwood output through Susie's factories. It was also designed to take Susie's shapes and patterns to a much bigger market. A new backstamp for the bone-china wares was created, stating that Susie Cooper was a 'Member of the Wedgwood Group'.

The 1960s were well under way. Ceramics designers, like those in the fashion trade, had to respond to the renewed demand for vivid colours and bold designs. Susie visited trendy Carnaby Street in central London in order to tune in to the 'Swinging Sixties' and acquire a taste of 'pop art'. Ever one for a commercial idea, she immediately created patterns 'of the time' such as Carnaby Daisy, Diablo and Gay Stripes. Modern and streamlined new shapes emerged, and her can shape gained further prominence.

Opposite:
A merger with Wedgwood in 1966 was intended to take Susie's shapes and patterns to a much bigger market. Nebula was one of several space-age patterns from 1968 which were produced under the Wedgwood banner.

Susie Cooper had her own Wedgwood backstamp. While only a few of her designs made it into production at Wedgwood, she was responsible for around thirty of the chinaware ranges in the Wedgwood catalogue in 1968.

Tea and coffee pots from the late 1960s Wedgwood era, including Nebula, Andromeda, Reverie, Hyde Park, Persia and Diablo.

WEDGWOOD
Bone China
Made in England
Susie Cooper Design
FLOWER MOTIF
SERIES B

Space themes were introduced as man headed for the moon, with Mercury, Neptune, Nebula, Andromeda and Saturn joining the existing floral and pop-art china ranges. Cups could be ordered with saucers in contrasting colours, creating a harlequin effect that struck a chord with 'hip' 1960s households.

Susie Cooper's output during the Wedgwood period was prolific but has been deemed rather forgettable by Susie Cooper purists and collectors. There were some great designs, as well as others that looked ordinary when compared with the heights of her earthenware creativity. She continued to develop bold ideas, but many were to languish in her studio as Wedgwood management ignored her efforts.

While only a small percentage of her designs made it into production at Wedgwood, she was responsible for around thirty of the chinaware ranges in the Wedgwood catalogue of 1968. This is thought to have been unprecedented in the company's history but still left Susie frustrated and underemployed.

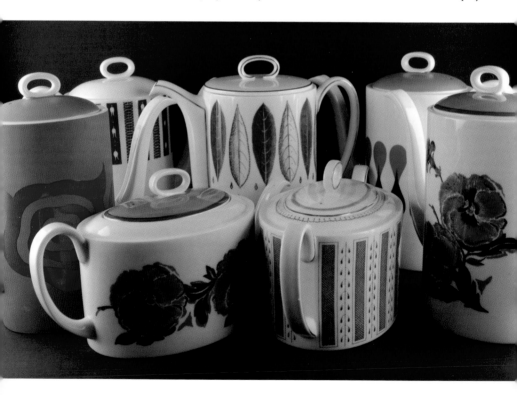

The death of Susie's husband, Cecil, in 1972 was another turning point. Her enthusiasm waned and her conflicts with Wedgwood management increased. She resigned her directorship of the company, but remained on the books as a designer. This gave her freedom to devote less time to tableware and more to decorative items, where she could develop fresh ideas.

In 1977 she produced lustre-decorated items sold in limited editions as souvenirs of the Silver Jubilee of Queen Elizabeth II. In 1979 Susie was awarded the Order of the British Empire, which was presented to her by Queen Elizabeth the Queen Mother, who had long been a fan of Susie's work and had bought many pieces from her pottery.

In 1980 Britain was entering a period of austerity and strife. Demand for British-made tableware had fallen, and the ceramics industry was struggling. Wedgwood was restructuring in an effort to save costs and jobs at its main factories. Susie's beloved Crown Works was closed. She was distraught, and her days in the Potteries were clearly numbered.

Following the closure of Crown Works, Susie was in danger of being completely sidelined by Wedgwood. She took up an offer from John Ryan of a studio in Tunstall at his William Adams pottery, a relatively independent Wedgwood subsidiary, to design earthenware. The sole resident designer at that time was Philip Gibson, later to emerge as a major talent for the art pottery Moorcroft. Furniture from her old office at Crown Works was installed in order to create a familiar and welcoming environment. She was encouraged to experiment, with technical help on hand for glazing processes and clay formulations.

Susie's role was supposed to have been part time, as she worked her way towards retirement. However, her enthusiasm returned and she was soon to be found on the premises virtually every day. She designed tableware ranges for the new breed of mass marketers such as Tesco and Boots, as well as reviving Blue Polka Dot for Tiffany's.

In 1982, when Susie reached eighty years of age, the Stardust and April designs were introduced to mark the occasion. She was once again combining style and practicality, with her patterns appearing on oven-to-table wares for the first time. There could have been a long and lasting relationship between Susie and Adams, but disagreements with Wedgwood management led her, in 1986, to leave the Potteries.

Coinciding with her departure from the Wedgwood group was a Kestrel reissue, reviving the shape for the first time in thirty years. Breakfast sets in three resurrected Susie Cooper designs were produced in 1987 by Wedgwood, namely Polka Dot, Pink Fern and Yellow Daisy. The small (12.8 cm high) Kestrel coffee pot in Pink Fern is particularly convincing as a 1930s throwback.

At the age of eighty-four Susie moved from Stoke-on-Trent to the Isle of Man. There she continued to work on a variety of projects, including the

restoration of her five-storey Victorian town house, and began campaigning for the preservation of the garden square in which it was located.

While her professional ceramics career was effectively over, she was to become the subject of great interest when a major retrospective exhibition of her work was organised by the Victoria and Albert Museum in London in 1987.

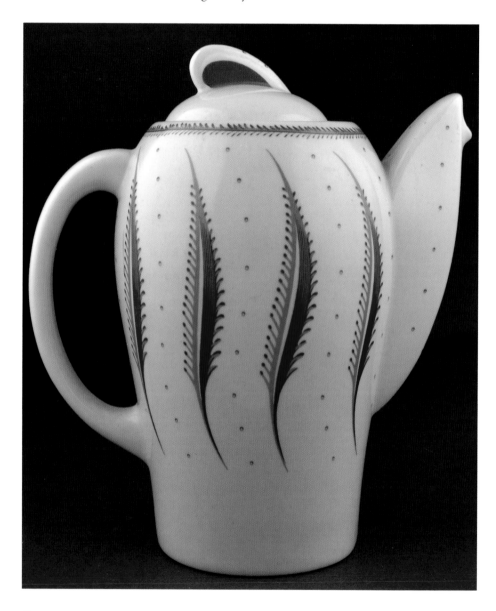

The show was exceptionally well attended, clearly demonstrating her importance and influence as a designer. In the same year she was offered (and accepted) an honorary doctorate from the RCA, while Stoke-on-Trent City Museum and Art Gallery held its own retrospective.

At home, she was working on some textile creations and a series of 'seed paintings' using a large variety of grain and seeds as the medium for depictions of animals and plants. In 1991 these were exhibited at Stoke-on-Trent City Museum and Art Gallery. She experimented with ceramic designs, and a range of lustre-decorated pieces came close to reaching production.

At the time of her ninetieth birthday in 1992 two books on her work were published and a porcelain model of her famed Leaping Deer was produced by the Shebeg Pottery on the Isle of Man in a limited edition of ninety. In the same year there were exhibitions at Wedgwood, and in 1993 Susie became an Honorary Doctor of Letters at Staffordshire University. She began to model a series of ceramic bookends, but these did not go into production until after her death in July 1995, and then in only very limited numbers. In October 1996 a memorial service took place at the parish church of St Peter ad Vincula in Stoke-on-Trent.

Wedgwood still owns the rights to Susie's designs, and in 2008 bone-china wares in the Kestrel shape (Polka Dot, Dresden and Wedding Ring) made an unexpected reappearance in a limited range sold exclusively by branches of John Lewis. The timeless shape seems destined to reappear occasionally among the displays of today's more mundane crockery.

Susie Cooper's career as a ceramics designer spanned almost seven decades. It took her from painting at Gray's in 1922 to heading her own hundred-strong business by 1939, before expanding into china in the 1950s and joining the board of Wedgwood in the 1960s. Even in the 1980s she was still a prolific and innovative designer and, as a consequence, there is a huge body of work for collectors to appreciate.

There is a perhaps understandable fascination with her hand-painted work of the 1920s and early 1930s, particularly as it reflects a glamorous era. In reality, Susie hit her stride when given the complete freedom to design shapes as well as patterns during the Leaping Deer years. Kestrel and Falcon are much more representative of her design ethos, particularly when paired with the pioneering transfer-printed motifs, wash-banding and aerographed finishes.

Opposite:
Coinciding with her departure from the Potteries was a Wedgwood Kestrel reissue, reviving the shape for the first time in thirty years. Breakfast sets in three designs were produced in 1987, namely Polka Dot, Pink Fern and Yellow Daisy. Shown here is the small Kestrel coffee pot in Pink Fern.

In 1993 Susie Cooper began to model a series of ceramic bookends, which did not go into production until after her death in July 1995. The Cockerel version is pictured.

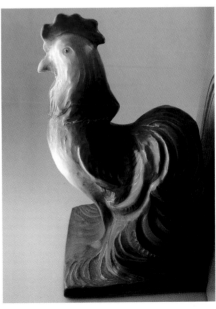

Susie was proud of her china output, particularly the designs such as Quail launched before the Wedgwood merger. This is an overlooked area and will surely become more widely appreciated and collectable. Perhaps the sheer volume of her output and the diversity of her styles act as a barrier for collectors and leave Susie Cooper unjustly in the shadow of Clarice Cliff.

Wedgwood still owns the rights to Susie's designs and, in 2008, bone-china wares in the Kestrel shape (Polka Dot, Dresden and Wedding Ring) reappeared in a limited range sold exclusively by branches of John Lewis.

FURTHER INFORMATION

PLACES TO VISIT

The Potteries Museum and Art Gallery, Bethesda Street, City Centre,
Stoke-on-Trent, ST1 3DW. Telephone: 01782 232323.
Website: www.stokemuseums.org.uk/pmag
Victoria and Albert Museum, Cromwell Road, London SW7 2RL.
Telephone: 020 7942 2000. Website: www.vam.ac.uk
The Wedgwood Museum, Wedgwood Drive, Barlaston, Stoke-on-Trent,
Staffordshire ST12 9ER. Telephone: 01782 371900.
Website: www.wedgwoodmuseum.org.uk

FURTHER READING

Casey, Andrew. *Susie Cooper Ceramics, A Collector's Guide.*
Jazz Publications, 1992.
Casey, Andrew, and Eatwell, Ann. *Susie Cooper, A Pioneer of Modern Design.*
Antique Collectors' Club, 2002.
Eatwell, Ann. *Susie Cooper Productions.* V&A Publications, 1987.
Joseph, Francis. *Collecting Susie Cooper.* Francis Joseph Publications, 1994.
Woodhouse, Adrian. *Susie Cooper.* Trilby Books, 1992.
Youds, Bryn. *An Elegant Affair.* Thames & Hudson, 1996.

INDEX